Aidan

Y0-AGJ-182

WHEN THE ANIMALS WERE PEOPLE

Copyright © 1983 by Kay Sanger

Published by Malki Museum Press
11-795 Fields Road, Morongo Reservation
Banning, CA 92220

Second Printing, October, 1989
Third Printing, October, 1997

ISBN 0-939046-32-6

Printed in the United States of America by
BookCrafters, Chelsea, Michigan

WHEN THE ANIMALS WERE PEOPLE

Stories told by the
Chumash Indians of California

Edited for children by
KAY SANGER

Illustrated by
TOM SANGER

MALKI MUSEUM PRESS
1983

Dedicated with love to
Kristin and Ted,
and with special thanks to
Thomas Blackburn and Georgia Lee.

Contents

Artifacts Illustrated
at the Ends of Chapters

Introduction

The stories in this book are only a few of the tales that were told and retold by the Chumash Indians of Southern California. The first person who wrote them down was J. P. Harrington, who studied the Indians between 1912 and 1922. These stories were later published by Thomas Blackburn in *December's Child* (University of California Press, 1975). The tales selected for this book have been carefully reedited in order to make them more readable for young people, but every attempt has been made to remain faithful to the original stories.

These tales were probably told by the older people at night around a large fire. Children as well as adults listened to the stories for entertainment and instruction. Some of the tales were intended merely for amusement, while others told of ancient Chumash beliefs. A few of the stories can be recognized as European folk tales that were learned and changed by the Indians.

Indian children who listened to these stories found answers to many of their questions about life's mysteries: how people were made, how the sun moves, where the stars came from and why the animals have certain traits. The stories also taught them how to behave. By observing the reactions of animals in the stories, children learned about human values.

According to Chumash belief, the First People who lived on the earth were much like the Chumash themselves, but they had both human and animal traits. In addition, they had many magical powers. They were able to do such things as fly with the wind, live under water and bring the dead back to life. The Chumash believed that these First People changed into animals or plants when a large flood occurred. The stories about events that happened before the flood often begin with the words, "When the animals were still people. . .".

Coyote was one of the First People, and a favorite character of the story tellers. Listeners could see him react to situations with animal-like cunning, or with a variety of human responses — sometimes with wisdom, other times with trickery and often with foolishness.

The Chumash believed there were three worlds. The world in which they lived was in the middle. Circular and flat, it formed a large island on top of water. There was a world below where dangerous monsters lived. There was also a world above, the home of Sun and Moon, as well as others like Thunder and the great Eagle chief. Two giant snakes held up the middle world from underneath. When they got tired, they moved, causing earthquakes. The great Eagle chief held up the upper world. When he got tired he stretched his wings a little and caused the phases of the moon. He also could create an eclipse of the moon by stretching his wings to cover it completely. The Thunder brothers made their sounds in the sky by playing a hoop and pole game, a favorite game of the Chumash people.

But of all those who lived in the upper world, Sun was the most important. He was an old man, a widower, whose two wives became the morning and evening stars. He lived with his two daughters and many pets in a large crystal house in the sky. Sun made changes in the world's weather depending on how high he carried his torch as he moved around the world each day. The stars were believed to be sparks thrown off of Sun's torch. On the other hand, Moon was thought to be a single woman who lived in a house near Sun.

The Chumash believed that many of the things which happened in their lives (and in their stories, too) were because of the great powers of these First People. They were blamed for such things as bad weather or praised when there was plenty of food. It was important to the Indians to know as much as possible about them. These stories helped teach the Indians.

The characters in these stories lived their lives in ways that were very much like the Chumash. The Indians lived in the warm, pleasant California climate where they could easily find food throughout the

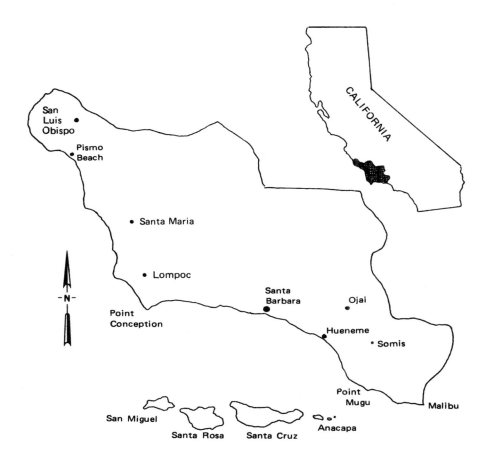

year. They didn't need to plant their food like their farming neighbors to the east. The land was full of plants, nuts and seeds they could gather and eat. They hunted many animals like deer, rabbits and birds. The Indians who lived near the ocean found plenty of fish and sea mammals to eat. It was a good life and the Spaniards who first saw the Chumash described them as healthy and good looking.

The Chumash lived in a large area of California between Malibu Canyon north of Los Angeles up to San Luis Obispo and from the Pacific coast to the western edge of the San Joaquin Valley. Many

places in California are still called by the names the Chumash Indians gave them: Hueneme, Lompoc, Malibu, Matilija, Mugu, Ojai, Piru, Pismo, Sespe, Simi and Somis. The Indians also lived on the Channel Islands of Santa Cruz, Santa Rosa, San Miguel and Anacapa that lie between 12 and 30 miles off the coast. They traveled between the mainland and these islands in large wooden plank canoes.

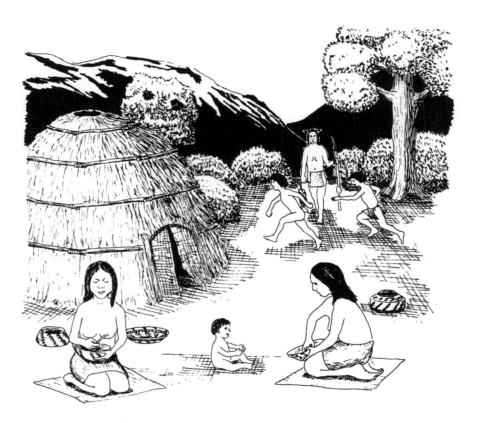

Their villages contained houses made of large poles covered with thickly woven grasses. These houses were round, with a cooking fire in the middle and a hole in the roof for light and ventilation. Sometimes just one family lived in a house; other houses were big enough for several families.

Every village had at least one sweat house which was dug into the ground and covered with a roof. These places were used by the people to relax and clean themselves. After building a fire in the sweat house, they sat near the fire until they perspired freely. Then they scraped the sweat off their bodies with long flat bones and jumped into a nearby stream or the ocean to cool off.

Each village also had a large flat area where dances and ceremonies could be held. Music was created with bone or wood flutes, accompanied by rattles made of such things as shells, cocoons and deer hooves.

The Chumash made many beautiful objects out of stone, bone, shell and wood. They carefully chipped away at stones to make arrowheads, knives and other tools. Fishhooks, pendants and beads were carved out of shell. Baskets were made with beautiful designs. They didn't make pottery, but they coated the insides of basketry bottles, to make them waterproof, with tar that oozed from the ground. Bowls were made of large shells, soapstone or wood. Some of these objects are illustrated at the end of each chapter in this book.

The Chumash were well known for their paintings on rocks and in cave shelters. They painted human and animal figures, as well as complex designs. The paintings were, and some remain, brightly colored. They are mainly red, black, white, yellow and orange. To make the paints, the Indians ground up rocks of different colors and mixed them with the whites of birds' eggs or milkweed juice. We don't know much about the meaning of the rock art. Some of the paintings might be illustrations of the stories they learned around the campfire. Drawings used at the beginning of each chapter in this book are copies of Chumash rock paintings.

Very little is left today of the Chumash culture. Their way of life was suddenly interrupted when Juan Cabrillo's expedition from Spain sailed into the Santa Barbara Channel in 1542. The Indian beliefs were shattered as the Spanish forced their religion and culture on the Chumash. By 1772, when the first of the California missions was built in Chumash territory, thousands of the Indians had died from diseases brought by the Europeans and because they couldn't

cope with the new way of life. Since then, most of their belongings have been carried away by private collectors or paved over by present day civilization. The rock art that remains is being steadily eroded by nature and attacked by the spray paint of thoughtless vandals. There are still Chumash people living today on the Santa Inez Reservation near Santa Barbara and elsewhere in Southern California. Many of them are active in trying to preserve their culture. We are lucky, indeed, that these recorded stories have survived.

There is little doubt that Chumash adults as well as children were influenced by and delighted with these stories. I hope that children and adults from our culture will now be able to share their enjoyment.

— Kay Sanger

How Centipede Got his Ugly Color

Long ago when the animals were still people, many of the young boys used to spend their time playing a special game. Every day they would gather around a tall, smooth pole to see who could climb to the top the fastest. The very best at this game was a boy named Centipede. He always won and bragged about beating the other boys. "I am the fastest," Centipede would say. "Nobody can climb to the top of the pole quicker than I can."

After a while the other boys got tired of hearing Centipede boast, so they went to see old man Coyote. Coyote had lived with his people for a long time. He was very wise, very clever and, best of all, he could make magical things happen.

"You have to help us, Coyote," the boys all pleaded.

Coyote scratched his long chin thoughtfully as he listened. "Yes, I think I can help you teach Centipede a lesson," he said at last. That night while everyone else was sleeping, Coyote placed his magic feathered string around the base of the tall pole and put a spell on it.

The next morning, the pole looked the same as always, but as each of the boys tried to climb it, he found the pole was much too slippery and he would fall off.

1

Soon it was Centipede's turn. Instead of slipping like the other boys, he started climbing as usual. But as he went up a strange thing began to happen — the pole started to grow taller. Try as he might, Centipede could not reach the top. Higher and higher he climbed until he became so tired he had to rest. When he looked down, Centipede discovered it was already nighttime below. He couldn't see the other boys. He couldn't even see his village and he became worried.

There was nothing for Centipede to do now but to keep on climbing. Up, up he went all through the night, into the next day, and still there was no top. Strong winds blew and he held on tight. The sun made parts of the pole so hot it was hard to hold, but Centipede kept on going.

At last he saw a light above him, coming from a door right in the middle of the sky, and there was the top of the pole. Gathering all the rest of his strength, Centipede climbed slowly up and through the door, letting go of the pole and sitting down to rest.

When he looked back through the door, Centipede was surprised to see that the pole had disappeared. It had shrunk back down and he now had no way to reach it. Centipede knew he could not go home. Alone in the sky with nothing but his sad thoughts, Centipede put his head in his hands and cried.

Suddenly he heard a buzzing sound that became louder. As he looked all around he saw a swarm of giant mosquitoes coming toward him. They stung him all over and soon sucked out all his blood. Finally there was nothing left of him but bones.

Away down below in the village, Coyote was beginning to feel sad and guilty about the magic trick he had played on Centipede. Because Centipede had never come back down the pole, the old man decided he would go after him. Casting another spell on the special pole, Coyote began to climb up, up past all the places Centipede had climbed before.

After a long time, Coyote finally came to the door in the sky and climbed through wearily, then sat down to rest. When he turned

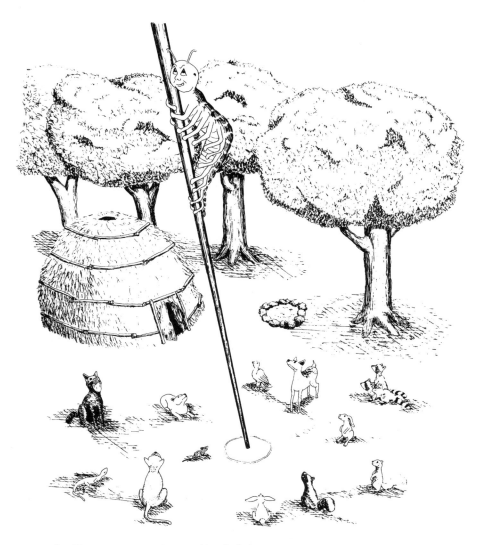

around, Coyote saw the pole shrink back down just as it had for Centipede. Now he, too, was lost in the sky.

When Coyote found what was left of Centipede, he used some special medicine they used to have that brought people back from the dead. Soon Centipede was well again, but he was no longer his normal bright color.

With Centipede once again healthy, the two friends now began looking for a way to get back home. Nobody could help them until they came to old Eagle who listened to their sad story, nodding his white head very slowly.

"If you will hop on my back, I will take you to the pole," the bird told them. "But you must climb the rest of the way back down yourselves."

Coyote and Centipede agreed and scrambled up onto Eagle's broad back. Away they soared into the air as Eagle flew them high over the clouds and then swooped down toward the pole.

When they were close enough, Centipede thanked Eagle and hopped off his back onto the pole. Coyote, who was much older and more weak from the long climb, leaped short of the pole and fell all the way to the ground where he landed with a terrible thump.

Centipede scurried down the pole very quickly as all the village people came running. Coyote's body lay broken on the ground and the people were very sad that the old man was dead. But Centipede would not believe it. He gathered all Coyote's bones together again and told all the people that Coyote was too smart to die. Soon they too did not believe their old friend was dead. They waited until, at last, Coyote revived himself and sat up and looked around at them.

Everyone was happy again, especially Centipede, who stayed as shiny as he always was, but his ugly color remained.

Coyote Goes to the Bottom of the Sea

One day when the animals were still people, Falcon went fishing in the ocean with Cormorant and Pelican in their large canoe. As the three boys were getting ready, Falcon saw a large sea bass. He quickly threw his harpoon at the fish, but he hurled it with such force that he fell into the cold blue water.

Before Falcon could climb back into the canoe, a swordfish came along and carried him away. Cormorant and Pelican waited all that day for their friend to come back up to the surface, but there was no sign of him. As the sun began to go down they sadly decided to give up their search. But before they left, Pelican looked carefully at the mountain peaks on shore so that he could find the spot again where Falcon disappeared.

Back in Santa Barbara Village where they lived, they told their chief, Eagle, what had happened to his nephew, Falcon. As they told him about the big swordfish and how long they had waited, Coyote overheard their story.

"You'll never get Falcon back unless you go down under the sea to get him," Coyote said. "The swordfish live in a village just like ours down there, but they are all men. They have no wives or children. And they are very strong. They play catch with whales, tossing them back and forth out of the water."

The chief knew Coyote was right. When Pelican volunteered to rescue Falcon from the swordfish, Eagle thanked him and said no. Instead he chose Coyote because he knew only a very clever man could succeed. Coyote protested, but the chief commanded him to go and bring back his nephew.

The next morning, Coyote left with Cormorant and Pelican in their canoe. The only things Coyote carried were a small cocoon of tobacco and some poison made from powdered toadstools. With Pelican again checking the mountains on shore, the boys took Coyote to the exact spot where Falcon had disappeared. After telling the boys to wait for him, he jumped into the water and swam straight down.

At the bottom of the sea, Coyote walked a long way until he found the house of the swordfish. It had eight windows and a magical door that talked, but it was all closed up.

"The swordfish have gone out hunting," said the door. Coyote gave the door a little tobacco. The door liked the tobacco so much it opened wide to let Coyote enter and then closed very quickly behind him.

When his eyes adjusted to the dim house, Coyote saw Falcon hanging from the ceiling, looking quite dead. At the center of the house he saw a very old swordfish lying in some ashes near the fireplace. The old man just watched him, not saying a word.

"Tell me," Coyote asked, "what kind of magic powers do your people have? Will they be angry when they see me?"

"You won't have to worry about their powers," the old man answered. Coyote didn't believe him. If he was to rescue Falcon, Coyote needed to know the swordfish magic. So he kept questioning the old man. When he didn't get the answers he needed, he decided to throw some of the poison powder at the old man. The swordfish immediately began to sneeze violently.

"Stop. I'll tell you what you want to know," the old swordfish gasped. "When they are about to arrive, a strong gust of wind comes. Then they throw some poles and clubs in the house. You will have to be careful not to get hit. Next comes a thick mist, first white, then

6

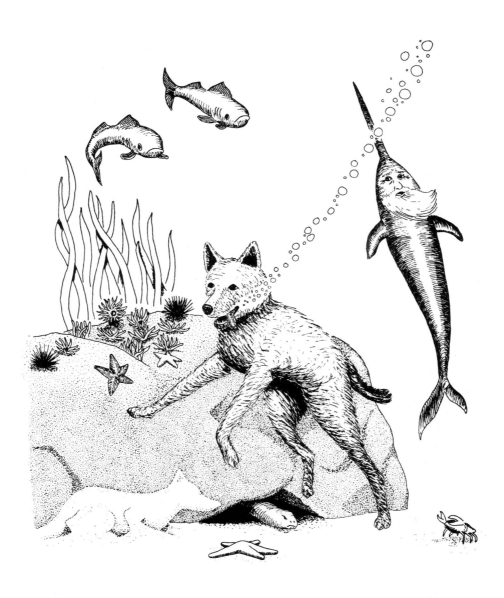

black. When that disappears there will be eight men here throwing down their catch of whales."

Coyote was worried now. "What can I do to escape these clubs?"

"I will hide you under some whale skins in the corner," the old man said. He covered Coyote up right away because it was almost time for the swordfish to arrive.

No sooner had Coyote settled down than a gust of wind shook the whole house. Then he felt the poles and clubs pounding down all around him and he was very glad to be so well protected. Coyote watched through a hole in the hides as a white mist came and was quickly followed by a black mist. When the darkness finally lifted, he saw the swordfish standing there. They looked like old men to him, with long beards, bushy white eyebrows and bone swords on top of their heads.

The men questioned the old man about the footprints they had seen on the way back home. The old man said he knew nothing. But the swordfish kept asking until he finally agreed to tell them everything if the men promised not to harm the stranger.

"You will find him under the whale skins," the old man said at last and the rest of the swordfish quickly uncovered Coyote.

"What are you doing here?" the men asked as they crowded around Coyote.

"I am here to bring back Falcon," Coyote answered bravely. "He is the nephew of the chief of our village."

"All right," said one of the men, "when do you want to leave with him?"

"Right now," Coyote replied.

"No, you must stay with us for a few days," said the biggest of the swordfish, who was thinking how good Coyote might taste. "We will show you how we hunt and where we go all day." Coyote protested at first, but he could see that he didn't have a chance of getting away so he agreed to stay for a while.

"Let's eat," one of the swordfish said, and they all began to tear steaks off the whale with their hands and teeth. Coyote shuddered at the sight of such strength, but he was disgusted by the way they ate. They were very different from the people in his village who politely ate acorn soup with two fingers.

The swordfish men started throwing huge whale steaks at Coyote, urging him to eat them all. Coyote knew he couldn't eat all that meat, but he was afraid of what the swordfish might do if he refused. Luckily he had his flute with him and he put it between his feet so it could not be seen by the swordfish. While the others ate, he put the whale steaks down the flute. They fell out the other end onto the ground where they were hidden from view. The swordfish were impressed with all the meat he seemed to eat and Coyote just smiled. All that night, however, Coyote tossed and turned, unable to go to sleep because he was afraid of the swordfish.

The next morning they insisted that Coyote go out with them on a whale hunt so that they could show him how strong and clever they were. The swordfish men ran hard and long to try to leave Coyote behind, but he kept right up with them. Quickly they each caught a whale, tossing it up in the air like a ball. Coyote managed to catch a whale too, by using his magic powers. Now the swordfish were becoming quite impressed with their visitor.

After the hunt, Coyote was hoping the swordfish respected him enough to let him leave with Falcon. But when he told them he was ready to go, they insisted he stay one more day to have a race.

"If you win," they told him, "you may take Falcon home with you. If you lose, you must go home alone."

Coyote had no choice but to agree. The man who was to race against him showed Coyote the course.

That night when the swordfish were asleep, Coyote crept out of the house and walked along the race course. He stopped and gathered up some sand and other material from the bottom of the sea and made a coyote that looked just like him. Using his magic, he brought the form to life.

"You are now a coyote like me," he told the sand coyote. "Tomorrow you will run the race for me when I get tired."

He walked farther along the course and created another sand coyote, telling it, "Tomorrow you, too, will run in the race just ahead of Swordfish until you get to the end and come back to the

first coyote. Then he will run for you. Swordfish won't have any helpers."

The next morning, Coyote and his opponent stood on the starting line. The starter clapped his hands slowly three times and the race started. The swordfish runner was much faster than Coyote in the beginning. But by the time he reached the first sand coyote, the swordfish began to tire.

Coyote stopped running and the sand coyote took off, quickly passing his opponent. The second sand coyote ran even faster and soon the swordfish runner was far behind. All the time Coyote lay near the starting place. Soon the racers reached the end of the course and started back. When the sand coyote reached the place where Coyote was waiting, he dropped out and the clever Coyote finished the race way ahead of the swordfish.

All the old men agreed that Coyote was the winner and could now leave with Falcon. But Coyote demanded first that the one swordfish who had taken Falcon away, now bring him back to life with his magic powers. When he refused, Coyote threw some poison powder in his face. The swordfish began to sneeze violently and finally agreed to revive Falcon if Coyote would stop the sneezing. Coyote cured the swordfish, who not only brought Falcon back to life but also guided them both back to the waiting canoe.

The people of Santa Barbara Village were overjoyed when everyone returned, and they held a huge feast in Coyote's honor.

Thunder and Fog

Thunder and Fog were brothers. One day they decided to visit their aunt who lived across the channel on Santa Cruz Island. They would have to be careful because her husband, Hap, was a very dangerous giant who created wild storms when he was angry.

Thunder tucked his flute in his belt and set out with Fog to find a canoe to take them to the island. Along the beach near Santa Barbara the boys found some men with a canoe who agreed to take them. The boys helped paddle the canoe across the channel, then said goodbye to the men who returned to the mainland in the canoe that same day.

The boys wandered all over the island and finally found their aunt in front of her house pounding acorns. She was surprised to see them. "Why have you come here when you know Hap will try to eat you? He's out hunting now, but he'll return soon," she warned them.

"We came for the adventure," they replied. She tried to convince them to leave, but when they told her they had no way to return to the mainland that day, she could only shake her head. Without another word, their aunt continued making the acorn meal, piling it into a large basket and all the while listening for her husband.

When Hap arrived that afternoon, he saw the boys and insisted they eat with him (to fatten them up). Hap only ate once a day, but he really ate a lot. Thunder and Fog watched as he swallowed a large basket full of acorn meal, basket and all, then spit out the pieces of basket afterwards. When he had finished eating, Hap suggested they take a nap with him.

Before he went to sleep, the giant put deer skins over the smoke hole at the top of the house so the boys couldn't escape. But Thunder used his magic charms to move the skins so that the arrow holes in them were lined up one over another. Then he blew a small feather up to cover the hole so Hap couldn't see it. Hap came in, shut the door tight and lay down with one arm around each boy. When they thought Hap was asleep, the boys got up quickly and their aunt put stones in their places. Then they squeezed through the little hole in the deer hides that covered the smoke opening.

When Hap woke up he was hungry. He took a deep breath and inhaled the rocks, thinking they were the boys. But when he felt the rocks in his mouth, Hap was furious and rushed out of the house to look for the boys. He was so angry he swallowed rocks, trees and logs each time he took a breath, then spit them out again. The earth was heaving up and down and moving backwards. Thunder and Fog raced ahead of him, but every time Hap took a breath, they were pulled back closer to his mouth.

Fog was frightened. "He is going to eat us. How will we get back across the channel to the mainland?" he cried.

"We'll have to let our Uncle Hap take us across," Thunder replied. They climbed to the top of a hill as Hap was taking a big breath. Thunder took out his flute and pulled on each end, stretching it much longer. He told Fog to grab on to one end of the flute while he held the other. When Hap saw them on the hill, he rushed toward the boys, ready to swallow them both in one gulp.

"Don't run away from him this time," Thunder told Fog. Hap came close and started to take a breath, but the boys turned the flute crosswise in his mouth and quickly climbed up to sit on either

12

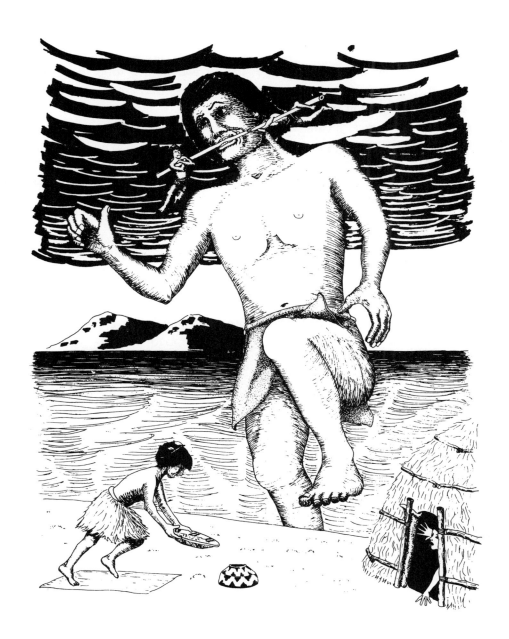

13

end. Hap couldn't see them sitting on the flute which was now clenched in his teeth, and he swam all the way across the channel carrying the two boys with him.

Soon they arrived on the mainland and before long they were over the Santa Inez Mountains near Santa Barbara Village. Hap continued breathing in the rocks and trees and making the earth slide and heave. He was getting very tired, though, because every time he took a breath, it used up more of his strength.

While all this was going on, Coyote was sitting in the mountains and watching as Hap rushed by. The boys were still perched on the ends of the flute and they called out to Coyote.

"Help us, Coyote. We don't know what to do."

"Remember the thorny tree," Coyote shouted back.

The boys had forgotten that they were approaching a special tree that had more thorns on it than any other tree in the world. They managed to yank it out of the ground as they blew by and Thunder threw it into Hap's mouth. This time as Hap took a breath he swallowed it. The thorns stuck through him all over and he finally grew weak and died. Thunder and Fog climbed off the flute and went back home.

They say that Hap made the gaps in the Santa Inez Mountains when he was chasing the boys, sucking in and spitting out the rocks, trees and dirt.

Coyote and Bat

Long ago when the animals were still people, Coyote and Bat lived together at the edge of the village. They hunted with each other and shared many things as good friends do. But Coyote was very jealous of Bat because he always seemed to do everything a little better than Coyote. Bat was very handsome, not at all as ugly as he is today. That was all Coyote's fault and this is how it happened.

Every day Bat watched the people of the village using their sweat house. They would go into the house, sit by the fire until they perspired heavily and then come out and jump into a nearby stream to clean themselves. The people saw Bat and told him he should use a sweat house, too, because it would help him feel good and stay healthy.

Bat finally decided to try it. "Let's build a sweat house together near the river," he said to Coyote. "It will make us feel better."

Coyote agreed to help. First they pounded mud and added twigs to it. Next they put poles in the ground, forming a circle and leaving room for a little door on one side. Then the two friends daubed the mixture of mud and twigs onto the poles, adding more poles and more twigs when needed. Finally they built a fire inside to harden the mud. It was evening when they put the final touches on the sweat house.

The next day Bat went out to find some logs to use for the sweat house fire. "If you gather the wood," Coyote told him, "I'll tend the fire." But all the while he was thinking to himself, "Here's my chance to do something better than Bat. I know I can stand more heat than he can."

So Bat went into the sweat house first and sat way in the back while Coyote stayed near the door at the front to tend the fire. Coyote kept stirring the fire and adding more wood until it was so hot Bat started gasping for breath. Coyote wasn't very hot because he was closer to the door and the cool air outside. He chuckled to himself, "Now I'm finally doing better than Bat. I feel so good, I could spend days in here."

Meanwhile, Bat wasn't feeling too well. He was about to choke from the heat when Coyote finally said, "All right, that's enough for now." They put out the fire and jumped into the cool water outside.

"Sweating is such good medicine. I feel good all over," Coyote bragged.

"Yes, I agree," replied Bat, who was feeling a little better. "Let's do it tomorrow again. But you can gather the wood and I'll tend the fire this time."

Coyote agreed, thinking to himself, "That's all right. I can stand the heat better than you, my friend, even if you make the fire hotter than it was today."

The next day Coyote brought the wood and Bat built the fire as planned. Bat was careful to stay near the door so that Coyote had to go back to the corner. Bat added more and more wood as the fire grew steadily hotter.

"I've had enough of this. Let's go out," Coyote said, pretending to gasp from the heat.

"Let's enjoy this just a little longer," Bat answered as he put more logs on the fire.

Coyote continued to pretend he was choking until Bat finally said, "All right, let's go cool off in the water."

Bat felt quite good this time. He told Coyote, "I feel wonderful. Sweating is certainly good for you."

"My head hurts and I feel sick," Coyote complained, pretending to feel awful, "but I'll go back tomorrow. It will be my turn to tend the fire."

So the next day Bat gathered the wood and Coyote built a large fire in the sweat house near the door. It was so big that Bat again had to move to the back of the house. Coyote kept adding handfuls of dry bark which made the fire burn hotter than ever.

"That's just right," Bat said. "You don't need to make it any hotter."

But Coyote didn't say anything and kept throwing on more dry bark. At last he moved away from the fire and pretended to go to sleep. Bat thought he couldn't stand the heat any longer.

"I think we've had enough. Let's leave," Bat cried out. But Coyote still pretended to be asleep.

"I've got to get out of here now," Bat gasped, running toward the door. But the fire was burning right in the entrance and Bat saw that he had to go through the fire to get out. He hesitated for a moment, then ran through it to the cool air beyond.

That is how he burned himself so badly that his face became scarred and ugly. His arms and legs grew together with a thin skin connecting them, too. Bat is still that way today and it's all Coyote's fault.

Duck and her Daughters

Long ago when the animals were still people, a woman named Duck lived in a village with her two daughters. She was Sun's first cousin. Duck was very proud of her older daughter who ate very little and worked hard all day making beautiful baskets. Her younger daughter, however, spent her whole day eating. Duck constantly had to be out gathering food for this daughter's large appetite.

Finally Duck could take it no longer. She was so upset that she decided to get rid of the younger girl so that she would be able to get some rest. That night when the girls were asleep she built a roaring fire. Then she carefully took her younger daughter out of bed and slipped her into the fire. The little girl never even woke up. She was immediately covered with fire and hot ashes.

The next morning the older sister wondered where her younger sister had gone. She was usually at home waiting to be fed, but this day she was nowhere to be found and the older girl was worried. After her mother went out during the day, she sat down sadly by the fire and began poking through the ashes with a stick, thinking about where her sister might have gone. When she uncovered the bones of her sister in the ashes, the girl was horrified.

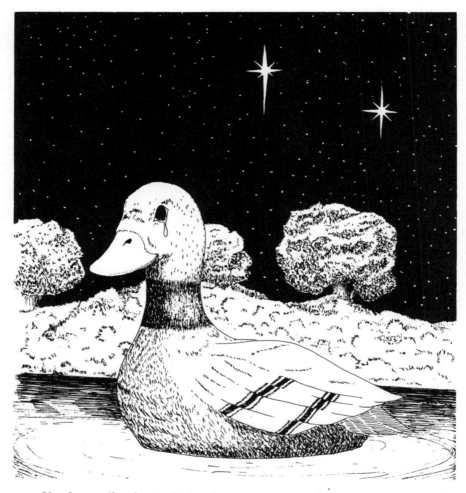

She immediately took the bones and placed them in a bowl with some water. Then she added some medicine that her people used to bring the dead back to life. After a little while her sister revived and was alive again. The older girl decided she would take her sister away at once.

"Eat all you need quickly, for we must go on a long journey," she told her little sister. The younger girl ate everything she could find in the house.

"Where are we going?" she asked.

"We will visit our uncle who lives far away," her older sister said. "Hurry, we must leave before mother comes back."

The two girls walked a long way until they came to a place north of Santa Maria where they found the path that climbs up into the sky. They kept walking up the path both day and night until the younger girl was about to drop from exhaustion.

The older girl was secretly carrying some tule roots in her hair. To encourage her younger sister to keep going, she threw some of the delicious roots on the trail ahead of them. The child ran ahead each time to eat the tasty roots and so the two continued to climb.

Meanwhile, Duck felt very sorry about what she had done and she missed both of her daughters very much. She cried for days and couldn't eat anything. Her cousin Sun saw her crying and took pity on her. He threw down piñon nuts to her, which he knew she loved. Finally she grabbed them and ate until she was full. But she was still so unhappy that she turned into a small duck called *Anucwa*. To this day she still flies around and makes sad sounds.

Meanwhile, the road to the sky was very long. Sun felt so sorry for the two girls that he finally shortened their journey. He told his daughters that when the two girls arrived they should be well treated because they were the daughters of his cousin. Then Sun went off to find a place where they could stay and he could keep an eye on them. Even now you can see them in the sky as the two small stars close to the Moon. The larger one is the older girl watching over her sister.

How People Were Made

One day, after a great flood that destroyed the animals on earth, Sky Coyote, Sun, Moon, Morning Star and the great Eagle decided it was time to make some people for the earth. They spent days discussing what the new people would look like. Lizard listened nearby but he didn't say anything. Finally, all the animals agreed on every detail, everything, that is, except for the hands.

Coyote said that people should have hands like his because he had the finest hands of the group. They argued for some time, but Coyote finally won. All agreed that people would have hands like Coyote's.

The next day they all met up in the sky around a beautiful table-like rock. The top of the rock had such a smooth surface that whatever touched it left a perfect print. The animals decided that the handprint of the new people would be stamped on this rock. Coyote raised his hand and was about to press it down on the rock when Lizard, who had been standing quietly just behind him, jumped out and placed his own handprint on the rock. Coyote was so angry at Lizard he wanted to kill him, but Lizard quickly escaped down a deep crack beside the rock. Sun and Eagle looked at Lizard's handprint and agreed that it really was more suitable for people than Coyote's.

It's a good thing for us that Lizard was so fast, otherwise we would have hands today like Coyote's instead of Lizard's.

Coyote Visits Sun

Once, Coyote met a whirlwind named Xoy, who spun around through the air. Xoy lived in the world above and Coyote wanted to go with him to see Xoy's home. Again and again Coyote asked if Xoy would take him. Xoy finally agreed and Coyote quickly grabbed Xoy's legs as the whirlwind started to spiral up into the air.

As Xoy went up faster and faster, Coyote became very frightened. He pleaded with Xoy to take him back down, but Xoy didn't answer. Coyote thought of jumping off, but when he looked down and saw how far above the ground he was, he held on tighter.

After a long time, Xoy took Coyote through a hole in the sky and into the world above. When Coyote realized he was in another world, he let go of Xoy's legs and dropped down to the ground.

Coyote knew there were three worlds. He lived in the middle world and knew that it was held up by two giant snakes who moved when they got tired, causing earthquakes. The world below Coyote's was full of dangerous animals. But Coyote realized he was now in the upper world, where Sun and his two daughters lived. Coyote looked around. He didn't know where Xoy had gone and he was beginning to feel lonely, so lonely that he sat down, looked at his world below and started to cry.

Finally he decided to walk to a beautiful big crystal house he could just see in the distance. He waited so he could arrive in the middle of the day, hoping he would be given something to eat. (It was just like him.) As he came closer, he realized that this was Sun's house. It was surrounded by lots of wild animals that Sun kept as pets — mountain lions, deer, bears, rattlesnakes and many others. One of Sun's bears tried to bite Coyote, but he jumped around it very cleverly. When he reached the front door, Coyote was invited in by Sun's daughters.

Coyote told them he had traveled a long way and was very hungry. Sun's daughters smiled and gave him a plate with a little bit of food on it — some acorn meal, piñon nuts, chia and a little piece of roasted meat. Now Coyote had heard that Sun was very rich, so he was disappointed that he had been served only a few bites of food. He ate it all in one big gulp. But when he looked at his plate again, there was the same amount of food. He ate that in a gulp and the same thing happened again. When he finally realized that was how they ate at Sun's house, he relaxed and finished his meal more slowly.

After eating, Coyote talked with Sun's daughters. He wanted to know where their father was and they told him that Sun would return in the evening.

When Sun arrived home after lighting the world all day, he wasn't very pleased to see Coyote. He took off his feathered headdress and wanted to relax. But Coyote was full of questions. "Where do you go? What do you see on your travels?" he asked.

"I don't see anything. I'm too busy traveling around," Sun told him. "Now let me get some rest. I have to be up early in the morning."

When they woke up the next morning, Coyote begged Sun, "Let me go with you around the world today."

"No," Sun said, "I'll be too busy to take you along." But Coyote pleaded until Sun finally agreed to let him follow.

They set out, with Sun carrying his firebrand, a torch of tightly rolled bark. They followed Sun's trail, which was a cord stretched

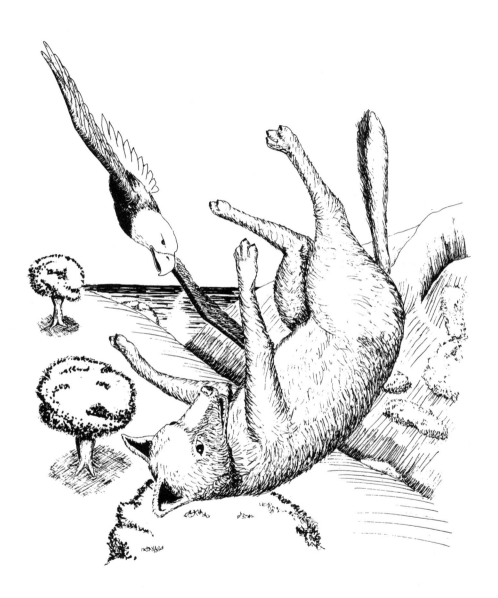

around the world. "Why don't you cut that cord? What do you need it for?" Coyote teased, trying to annoy Sun.

"Don't cut that string or we'll both fall down to the earth below," Sun said. Coyote followed closely behind Sun and watched how he carried his firebrand to warm the earth. Later when they were resting for awhile at midday, Coyote said, "Let me carry the torch for awhile now. I've been watching you and I know how to do it."

"I can't let you do that," Sun replied. "If you don't carry it properly you could burn up the whole world below." But Coyote begged some more and finally Sun handed him the torch.

Coyote started off carrying the torch just right, but soon he began to hold it too low and the people here on earth were getting burned. They began jumping into springs and rivers to cool off. The world almost burned up before Sun finally grabbed the torch back. After that Coyote just followed behind Sun again until he set and they returned to the crystal house.

The next morning Coyote didn't want to go with Sun again. He was getting homesick and wanted to figure out a way to get back down to his own world. Coyote walked back to the hole in the sky where he looked sadly down on the earth below. He had just about given up all hope of returning, when two eagles flew up and said, "Coyote, what are you doing here? Don't you want to go home?"

"Oh, I guess so," Coyote said, trying to sound brave.

One of the eagles told Coyote to hop on his back and they started down through the air. Listening to the wind singing through the eagle's wing feathers, Coyote was filled with envy.

"Give me some feathers so that I can fly by myself and make that lovely sound," he said foolishly.

"Don't be silly, Coyote. You can't fly. You'll fall to the ground and be killed," the eagle answered. But Coyote wanted to fly so badly that he started to pluck some of the feathers out of the bird's neck to make his own wings.

Eagle got so mad he threw Coyote off his back, sending him tumbling toward the earth. When Coyote had fallen almost halfway,

Eagle began to feel sorry for him and swooped down to grab him. But Coyote was falling too quickly and Eagle couldn't catch him before he struck the ground and was killed.

Fog and his brother Thunder were nearby and saw Coyote fall. Thunder ran up to him and was able to use some magic he knew that brought Coyote back to life.

Coyote sat right up. "Oh, what a good sleep I had," he said with a yawn. He would never admit that he had been dead. The two brothers asked him where he had been and what he had seen. Coyote told them everything he had seen and that's how people know about Sun and the upper world today.

Rabbit and the Tar Dolls

One day when Rabbit was hopping along, he discovered a small patch of delicious melons growing near the path. Someone had put a fence around the plants, but Rabbit found a little space he could just squeeze through to get inside. He ate a melon that was so delicious, he decided to come back every night for a treat. Rabbit looked around before he left and found four different holes in the fence he could use to get into the melon patch.

The man who had put up the fence came along a few days later and said to himself, "Someone's been eating my melons." He looked around the fence and soon found some rabbit tracks leading to four tiny openings. "Ah ha. I'll have to catch this little thief."

The man went down to the beach and collected lots of tar which he used to make four little human looking dolls. He put one in each of the four spaces that the rabbit had been using to get into the patch. Then he went home, confident his plan would work.

Later that night, Rabbit came as usual to feast on the melons. But when he got to his opening in the fence, he found he couldn't get in because a little tar doll was blocking the way.

"That's strange," he thought. "I'd better try one of my other entrances." He ran around to the next opening, but he was surprised to find his way blocked again.

"He got here ahead of me," Rabbit said to himself. "I'd better run as fast as I can to the next entrance."

But when he got to the third hole he was upset to find the tar doll standing in his way again.

"He is faster than I am. I'll try asking him to move."

So Rabbit walked right up to the doll and said in his very loudest voice, "Come on, let me in! My house is in there." But the doll remained silent and Rabbit was losing his patience.

"If you don't move right away I'll hit you in the stomach," he shouted. When the doll still didn't say anything, Rabbit became very angry. He punched the tar doll in the stomach as hard as he could. But when he tried to pull back his arm, he realized it was stuck in the tar. Rabbit was so mad he hit the doll with his other hand, but that became stuck, too.

"If you don't let me go I'll kick you," Rabbit warned. Then he kicked the doll and his foot got caught in the tar. By this time Rabbit was so upset he kicked the doll with his other foot. Poor Rabbit. Now both his hands and feet were stuck in the tar. All he could do was lie there and wait for someone to come along and help him.

The man came back the next morning and found Rabbit stuck to the tar doll. "Now I've caught you, my melon thief," the man chuckled. "I'm taking you home to make Rabbit stew."

He pulled Rabbit out of the tar and took him home, where the man tied him upside down by his hands and feet to a low branch of a cottonwood tree. The man then placed a big pot of cold water directly under Rabbit.

"You wait there, my little thief, while I go inside and prepare the rest of the meal," he said as he disappeared inside.

The man had been gone a short while when Coyote came along and saw Rabbit hanging from the branch.

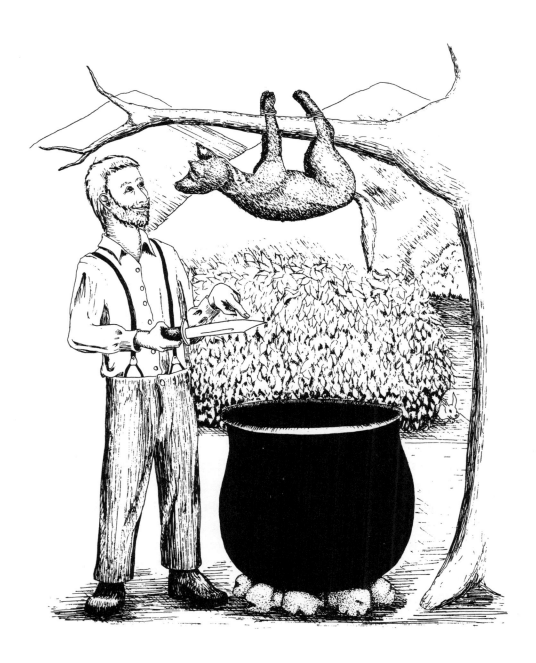

"Why are you hanging like that up in the tree?" he asked.

"Because," said Rabbit, thinking quickly, "the man in that house insists that I marry his daughter and I don't want to. He said he would boil me in this big pot if I don't marry her."

"Well, I'll marry her if you don't want to. I'd like to get married," Coyote said eagerly. Rabbit was delighted, but he tried not to show it.

"Alright then, untie me," he said. Not only did Coyote help Rabbit down but he also insisted that Rabbit tie him back up there the same way. Rabbit was happy to help, tying Coyote's arms and legs to the limb of the tree hanging over the caldron. Then Rabbit hopped away and hid in some nearby brush so he could see what happened.

When the man came out of the house he was shocked. "My melon thief has turned into a coyote," he cried. "I'd better cook you right away before you turn into something else!" He quickly lit a fire under the pot and, as the water began to boil, Coyote realized he had been tricked.

Coyote summoned all his strength and as the man began to cut the rope that held him above the big pot, Coyote twisted away and landed on the ground just beside the boiling water. Unfortunately, his tail fell into the water and was burned a little. But before the man could catch him, Coyote picked himself up and darted off.

When he ran past the brush where Rabbit was hiding, Rabbit called out, "Hey, Burned Tail!"

"If I catch you I'm going to eat you up," Coyote growled as he turned and chased after Rabbit.

Rabbit was fast and soon outran Coyote, but Coyote searched all through the night until he finally came upon him the next morning in a deep ravine with steep overhanging sides and no way out. As Coyote approached, Rabbit thought a moment and then put his hands on the steepest wall of the ravine and pretended he was holding it up.

"Now I'm going to pay you back for what you did to me," Coyote said.

"Look up, brother," Rabbit replied. "The walls of this ravine are about ready to fall in on us and we will both die. I'm trying to hold up this wall but I'm getting tired. I don't know how much longer I can do this."

Coyote looked up at the overhanging cliff and was a bit frightened. "What can I do?"

"You are stronger than I am," Rabbit answered, "so you could take my place holding up this wall. If you do that, I'll go get us two chickens to eat."

"How do I know you'll come back?"

"Oh, I promise I will," Rabbit told him. "Now come here. I can't hold this much longer."

Coyote finally took Rabbit's place and Rabbit gleefully hopped away. Coyote was afraid that the wall might cave in on him at any moment, so he pushed hard to keep it up. But after a long time he got so tired he knew he couldn't hold the wall much longer. He decided to let go and jump as far back from the cliff as he could, hoping it wouldn't collapse on him.

He made a very great jump and landed a long way from the wall. When he turned to look at it, he realized he had been tricked again because the wall was still standing without his help.

Coyote was furious at being tricked twice and vowed to eat Rabbit for sure if he ever found him again.

Coyote and Skunk

One day when Coyote was looking for something to eat he came upon Skunk who was gathering some prickly pear cactus. Now Coyote had never eaten a skunk before but he was so hungry he decided he would have to force himself to do it.

"Little brother, I'm going to eat you because I am so hungry," Coyote said.

"How can you eat me?" answered Skunk, who had already figured out how to escape. "I'm gathering this cactus to take back to everyone in the village."

"Give me some to eat then," Coyote demanded.

"I can't share it because it's for the people in the village."

"If you don't give me some, I'll eat you," Coyote growled. So Skunk cut off a piece of the fruit and gave it to Coyote. He liked the sweet taste of the cactus and asked for more right away. Finally, when he had almost eaten his fill of the fruit, he said, "Give me that last piece."

But Skunk had a plan. "Open your mouth wide and tilt your head back so you can look up at the sky," he said.

Coyote did as he was told, but instead of the cactus fruit, Skunk threw a handfull of cactus thorns at his eyes. Coyote yelled in pain and rubbed his eyes with his paws, which only made the thorns go in deeper. When Skunk saw that Coyote couldn't see, he ran away.

Coyote wandered away blindly hoping to find some water to bathe his eyes. He soon fell down a ravine that had a pool of water at the bottom, where he washed his eyes and managed to pull out the thorns so that he could see again.

By this time he was so angry he vowed to find Skunk again and eat him quickly. He hunted for Skunk all day and at night he was able to continue his search since there was a full, bright moon. Finally he found Skunk's tracks and followed them to a spring where Skunk was getting a drink.

"Now you can't escape little brother," Coyote said. "I'll eat you this time."

"I'm not very big. I won't fill you up," Skunk replied. "But look at all that cheese out there in the water," he said, pointing to the big round reflection of the moon. "That would fill you better than I would."

Coyote had to agree that he would be more satisfied if he ate a lot of cheese, which he really liked, than if he ate one small skunk. So he said, "Well, how can we get that cheese out of the water?"

"The only way we can get to it is to drink up all the water in the spring." said the clever Skunk. "I'll help you and then you may eat all the cheese. I'm not very hungry."

Coyote was quite pleased and he began to drink the water. Skunk only pretended to help. After a while Coyote was so full of water that it was coming out of his nostrils. He couldn't even walk. When Skunk saw this he quickly ran away.

Poor Coyote lay beside the spring all night, shivering in the cold. By morning he could move again. When he looked at the spring in

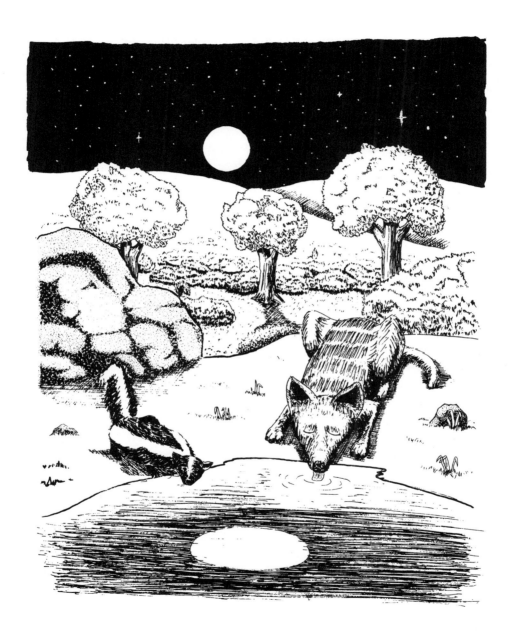

the bright light of day, the moon's reflection was gone, of course. Now he was really angry. "I won't let Skunk trick me three times. This time I will eat him for sure."

Coyote searched all morning and finally found Skunk sitting on a rock with a stick in his hand. Coyote didn't know that Skunk had found a wasp's nest in a hole in the ground and had covered the opening with the rock.

"You've tricked me twice. Now little brother I'm going to eat you."

"You can't do that," Skunk replied. "I'm needed here. I'm teaching some little boys."

"Where are they?" Coyote asked, ready for another trick.

Skunk hit the ground near the rock with his stick and the wasps buzzed angrily. To Coyote the noise sounded like a lot of little boys were just under the ground. Then Skunk said, "I'm very thirsty. Will you please take over for me while I go down to the stream to get a drink?" Coyote was delighted because he realized he could eat the little boys while Skunk was away.

As soon as Skunk left, Coyote began to dig near the rock with his stick. But when he opened up the hole, instead of little boys he found only wasps who swarmed all around and began to sting him. Coyote jumped into the nearby brush and rolled around in it until the wasps finally flew away. He was stiff and swollen when he walked back to the spring to sit in the cool water. After a while he felt better and he vowed to eat that skunk next time for sure.

Coyote followed Skunk's tracks again until he came to a cane patch. There was Skunk right in the middle pulling cane to make a clearing.

"I'm going to eat you now," said Coyote as he approached. "None of your tricks this time."

"Why do you want to eat me now when I'm working so hard getting ready for the fiesta?" Skunk asked.

"What fiesta?" Coyote said, immediately forgetting how cunning Skunk was.

"There is going to be a big fiesta here with plenty of chicken and other good things to eat," Skunk told him. "If you eat just me you won't get very full. But if you help me get ready for the fiesta, I'll get you much more to eat." Coyote, the silly fellow, agreed to help.

"Now, when the people start to arrive, you will hear lots of firecrackers," Skunk explained. Coyote began to work, pulling up the cane and listening for the first sound of firecrackers. Skunk left for a minute and started some little fires around the cane patch. Soon the fires began to crackle and pop as the cane burned.

"You can hear the people coming now," said Skunk. "Those are the firecrackers." Then as the fire came closer, Skunk ran through the last remaining space between the flames.

"That Skunk has tricked me again," shouted Coyote. All he could do was run through the flames. He burned his feet and scorched his hair, but he knew he would be all right. As he limped away, he thought to himself, "My brother Skunk is very smart. I'm tired of being tricked by him. I'd better leave him alone after this."

And Coyote never tried to eat Skunk again.

Designed and
Set in Univers type by
Helen Walton Curtis

Illustrations and Decoration by
Tom Sanger

Printed by
Rubidoux Printing Co.
Riverside, California